Carving an American Eagle

with Paul White

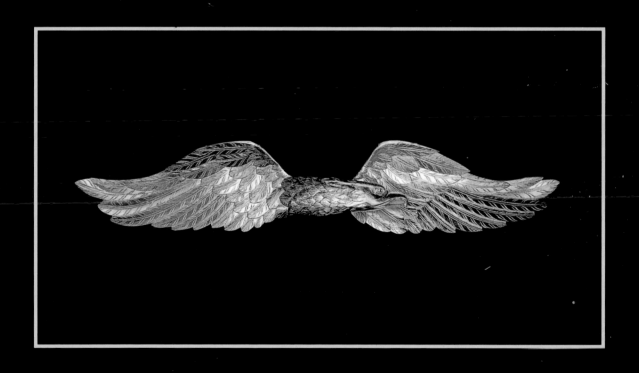

**Text written with
and photography by
Douglas Congdon-Martin**

77 Lower Valley Road, Atglen, PA 19310

ACKNOWLEDGEMENTS

I wish to thank The Wooden Fin and Feathers for providing the blanks demonstrated in this book, George Chakar for helphing prepare the eagles for carving, and all those who have shared and continue to share their knowledge with me.

DEDICATION

To Karin

CONTENTS

Printed in China
ISBN: 0-88740-624-6
We are interested in hearing from authors with book ideas on related topics.

Published by Schiffer Publishing Ltd.
77 Lower Valley Road
Atglen, PA 19310
Please write for a free catalog.
This book may be purchased from the publisher.
Please include $2.95 postage.
Try your bookstore first.

INTRODUCTION

The eagle as an American symbol is nearly old as the nation itself. Those who sought to separate us from the bonds with England knew that the nation would need symbols to help it establish its identity. They wanted a flag, and, as the story goes, commissioned Betsy Ross to fashion the prototype. They also needed a seal, something that would identify the new entity they were seeking to forge. Ten days after the Declaration of Independence was signed a committee was appointed to design this new symbol. Its membership included Benjamin Franklin, John Adams, and Thomas Jefferson. The eminence of these personalities should give us some idea how important the task was.

Eminent or not, they were not a particularly productive committee. According to Allan S. Woodle, who reviewed the history of the carved eagle in *Fine Woodworking* in 1976, Franklin proposed a design using Moses lifting his staff to part the Red Sea, and to make it come back to drown the Egyptians in pursuit. Jefferson wanted to portray the Israelites wandering in the wilderness, with the Saxon Chiefs, Henguist and Horsa, on the reverse side. Adams wanted "Hercules being urged by Virtue (a maiden) to ascend the mountains while the figure of Sloth reclines on the ground."

As Woodle pointed out, we carvers are lucky that none of these suggestions caught the imagination of the Continental Congress. Instead they looked to the design of William Barton, from Philadelphia, who is said to be the first to submit a design with an eagle. Refined by Charles Thompson, also of Philadelphia, it was adopted by the Congress in 1783. It has survived largely intact to this day and can be seen on the back of every one dollar bill. The bald eagle holds thirteen arrows in one talon, one for each colony, and an olive branch with thirteen berries and thirteen leaves in the other. In its beak is a banner with the words E. Pluribus Unum. On its breast is a shield with thirteen stripes and above its head is a crest with thirteen stars.

The design met instant popular approval and citizens began to use it in a variety of decorative ways. For the carver it was a tremendous design. People began to seek eagles for their homes and places of business. They were popular adornment for public buildings, and the great ships of the day were more than likely to have a gilded eagle somewhere on their prow.

Two hundred years later the eagle continues to be as popular as it ever was, and for the carver it is a natural subject. The varieties are endless, from the static eagle of the national shield to the dramatic eagle that we carve in this book. I have tried to give you some of the possibilities for eagles in the gallery of this book. A look at some of the books in the Bibliography will show you many other ideas. The techniques you will learn in these pages should go a long way toward enabling you to carve any eagle you may encounter. I hope you enjoy the project, and go on to create a whole flock of these glorious birds! Happy carving.

PATTERN

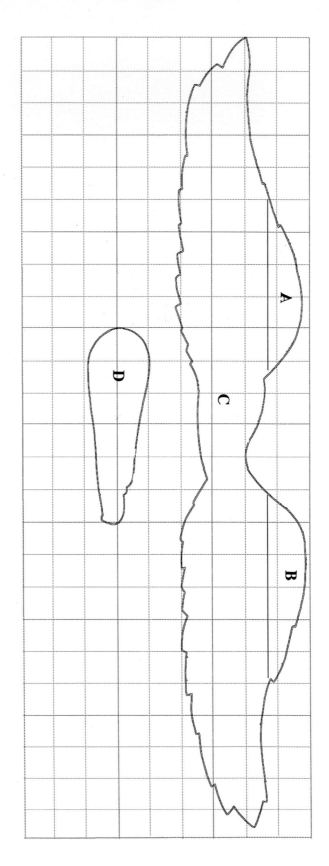

SCALE: 1/2 inch = 6 inches
1 block is 2" x 2"

PREPARING THE WOOD

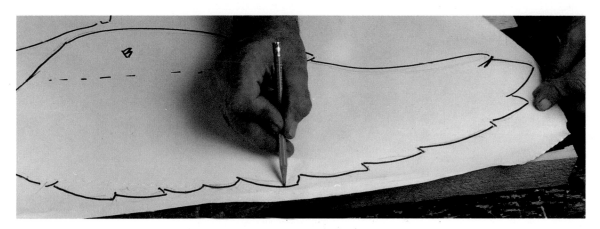

To begin from scratch you will need a piece of straight grained wood. Pine, mahogany or bass wood are most commonly used. The most stable wood has the end grain running vertically to the face. I am using western sugar pine. A full size eagle will be cut from a piece 50" x 12" x 2". It has to be 11.5" wide and as close to 2" thick as you can get. The pattern is in four pieces, the whole wing span, the head, and the top edges of each wing. Lay the pattern on the board and insert carbon paper to transfer the pattern. To the wing span...

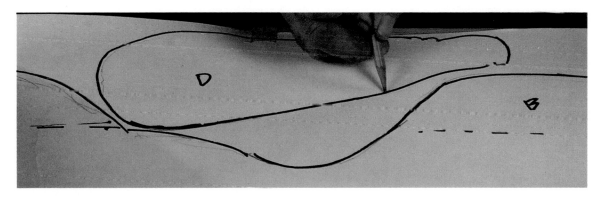

and the head.

I move the pattern to trace the wing edges, although the pattern in this book has the pieces drawn out separately. Be sure that all four pieces have the grain running in the same direction.

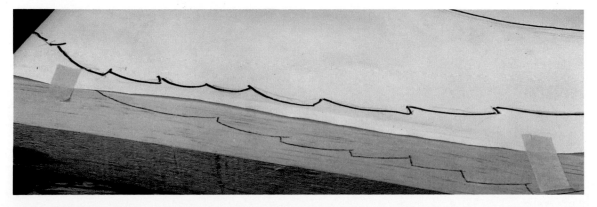

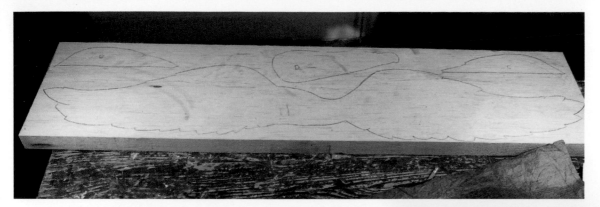

The pattern drawn. If you are thinking of making more than one eagle, you may wish to cut the patterns out of Masonite.

I generally cut apart the pieces before doing any close work.

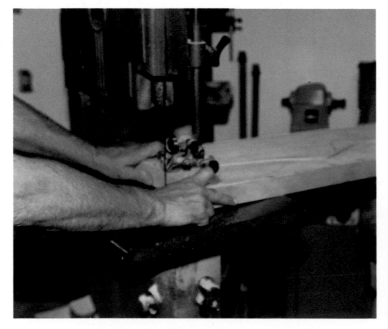

Then, to make the piece lighter and easier to maneuver, I make a rough cut around the pattern.

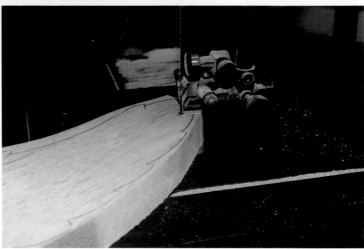

Make stop cuts in the short lines of the feathers.

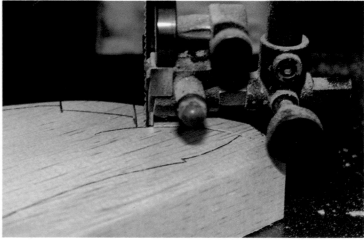

Cut back to the stops along the long edges of the feather.

Continue up the wing.

Cut the curve at the neck.

Cut the other pieces.

Continue at the top edge of the wing.

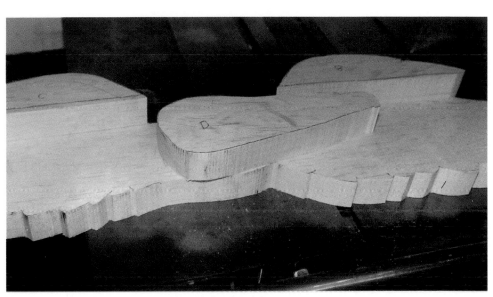

The bandsawing complete.

Go back and clean up the sawing. I usually try to make the bandsawing as efficient as possible, doing as many cuts in one direction before I have to turn the piece around or over and cut in the other direction.

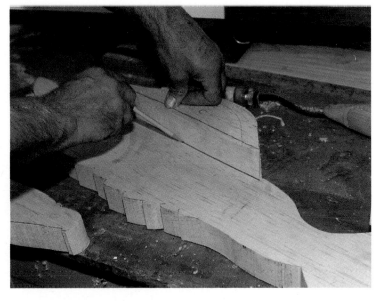

Before gluing the pieces in place, mark the position of the wing edges.

If the eagle is going outside, use a good waterproof glue like a Weldwood two-part Waterproof Glue or epoxy. Since ours is destined for inside use only, we will use carpenter's glue. Apply glue to both surfaces...

The clamps are now easily applied. The holes can be filled later.

and glue in place.

This gets set aside. The head will be rough-carved before being glued to the body.

Index tacks from opposing directions will hold the piece in place. Don't set the tacks. Leave them raised so they can be pulled later.

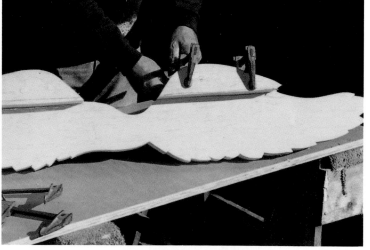

When it has thoroughly dried, unclamp the piece...

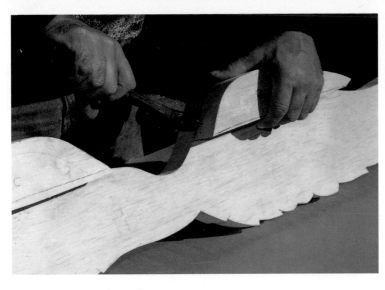

and remove the nails.

When the angle of the wing edge is roughed in, mark the position of the head before shaping the wing further.

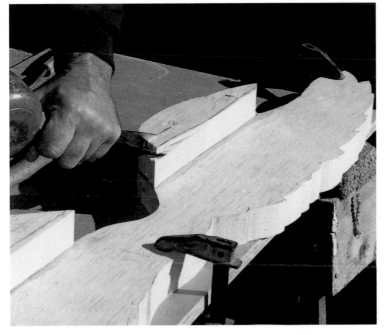

Rough shape the top edges of the wings. A wide gouge and a mallet...

Move to the wing and start removing wood near the bottom.

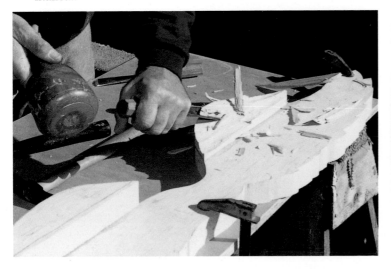

can remove a lot of material when going with the grain.

Begin to shape the cup of the wing.

Change direction so you are cutting across the fiber of the grain instead of into it.

Continue to carve out the concave surface of the wing.

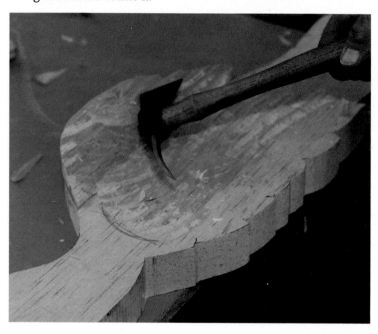

A sculptor's adz is useful for removing large amounts of wood like this.

The adz pretty quickly takes it to this shape.

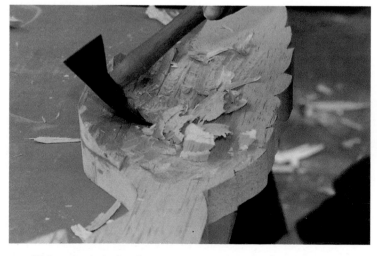

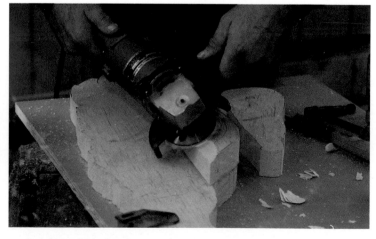

Using short strokes it removes a great deal of material in a short period of time.

An alternative for preparing the wood is to use power. This is a 4" disc grinder with a wood carving blade. It comes in a number of sizes. This is the coarsest and should be used with great care and the proper safety equipment.

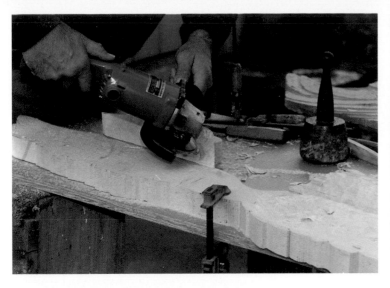

The carving head makes the work easy...

Use your pattern as a reference to draw in the main layers of the feathers.

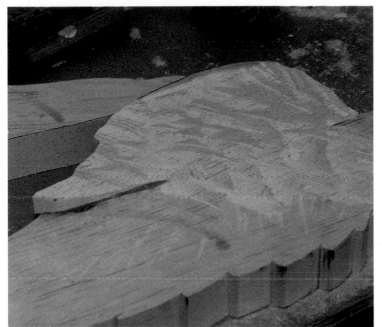

taking the wing to this point.

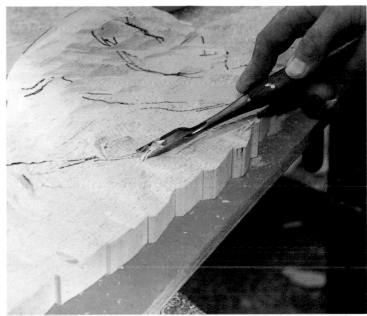

Go over the lines with a large v-tool to define and relieve the area.

Switch to a sanding disc of about 20 grit to continue stock removal.

The result.

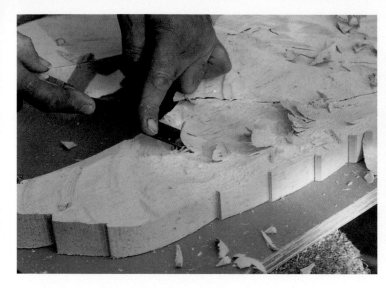

Create the plane of the feathers. This can be done in large bites.

When you've created the contour you want on the first section move to the next.

Deepen the relief cut...

Continue up the wing doing one segment...

and remove some more.

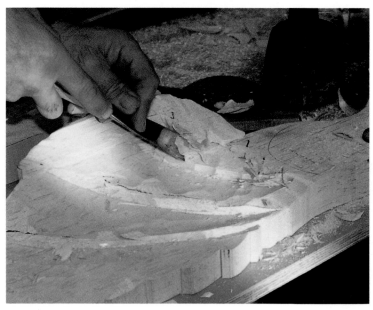

at a time...

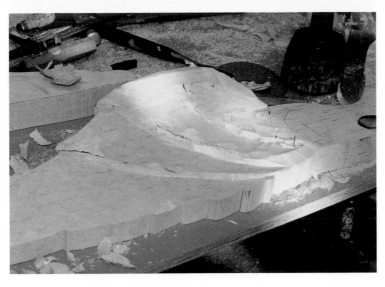

until the shaping is finished.

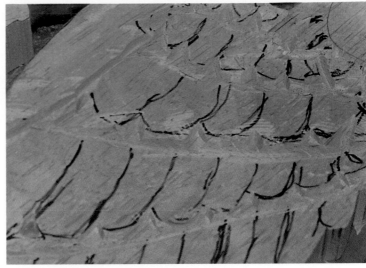

The ends of the feathers relieved and defined.

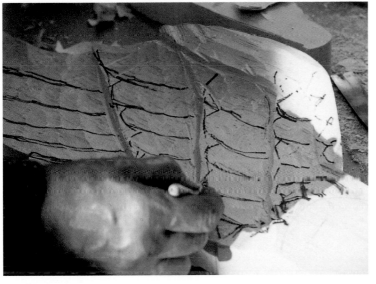

Refer to the pattern to draw in the lines of the feathers.

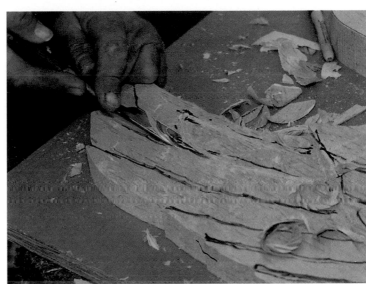

Create the edges of the feathers...

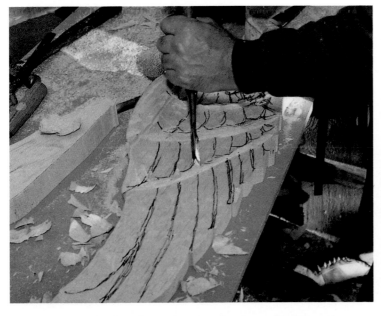

Use a v-tool to knock out the triangle of wood between the feather tips.

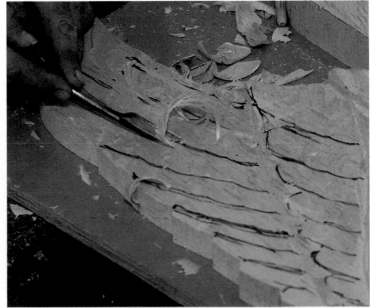

by going over the lines with a v-tool.

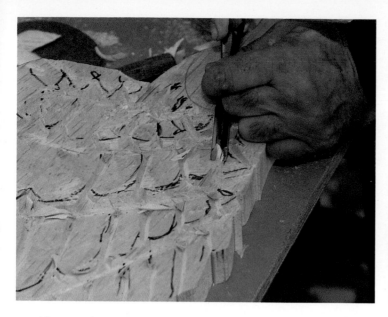

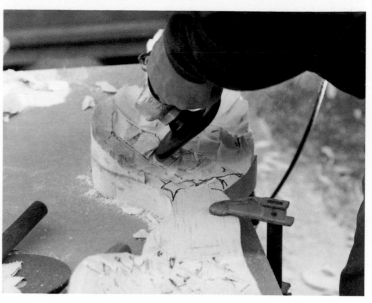

Always take a test cut to check the grain direction, and, if it works, cut the line in a nice smooth stroke.

then use the edge to define the feathers.

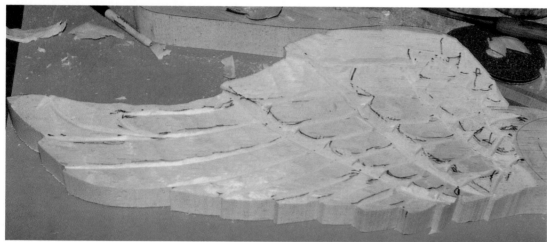

With that the wing is defined.

The grinder will give you a faster, if cruder, roughing in.

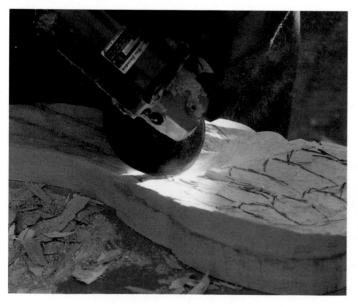

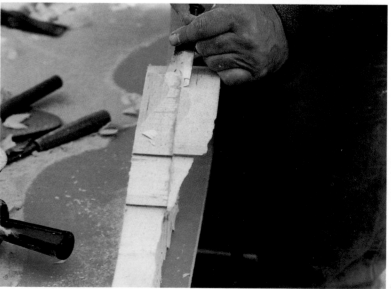

The same thing can be done with a grinder. First define the levels...

You need to bring the back side of the wing down, which you can do by hand...

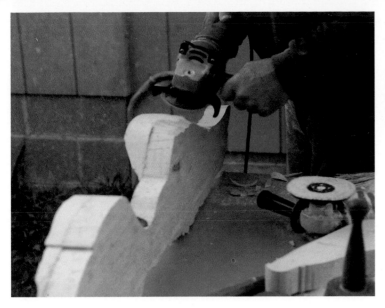

or with power.

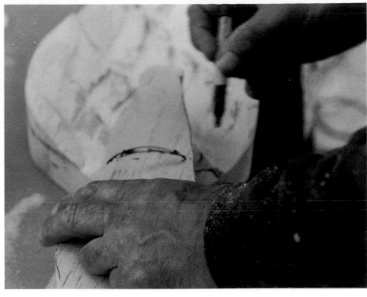

Mark the head's position on the body, matching it with the mark you made earlier on the body.

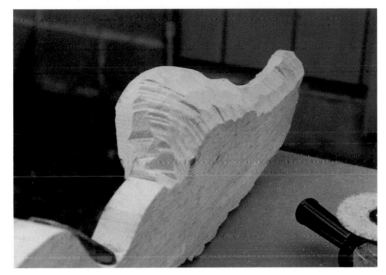

The more you can remove from the back, the lighter the wing will appear.

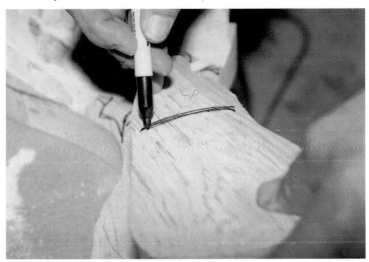

Carry the line around to the back of the head.

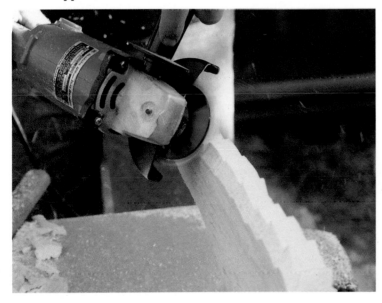

Do the same on the bottom edge.

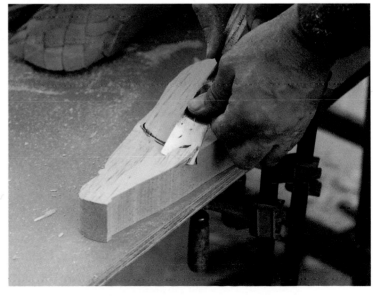

Starting at that line, thin the back of the head, tapering toward the end of the beak.

You can do this by hand or with power.

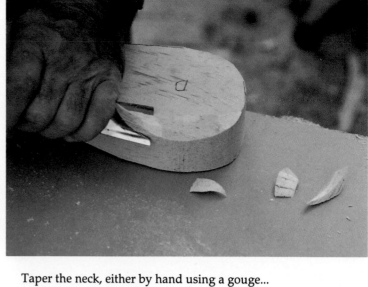

Taper the neck, either by hand using a gouge...

When you place the head on the wings, you can see the kind of taper you are after.

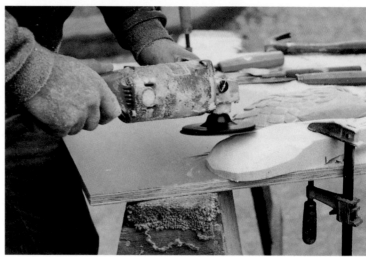

or with power.

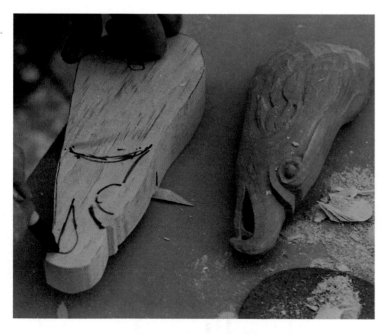

Draw in the major lines of the head and beak.

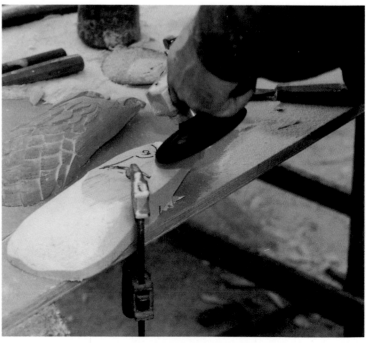

The grinder can be used to set the major shapes of the face.

Ready for marking.

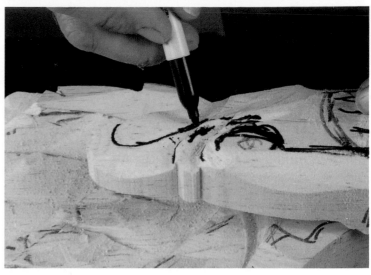

and facial details.

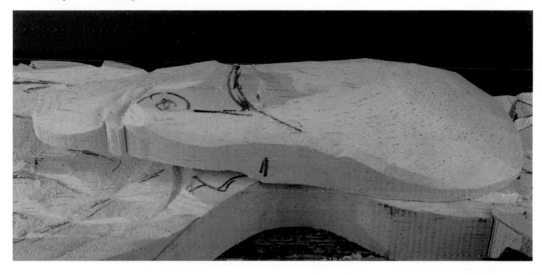

Situate the head on the body

Relieve around the feathers...

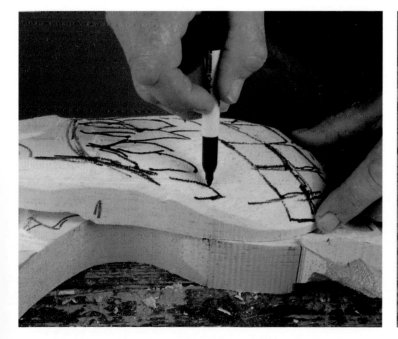

With the pattern as a reference draw in the lines of the feathers...

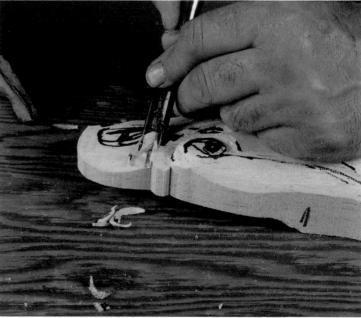

and the lines of the face.

USING A COMMERCIAL BLANK

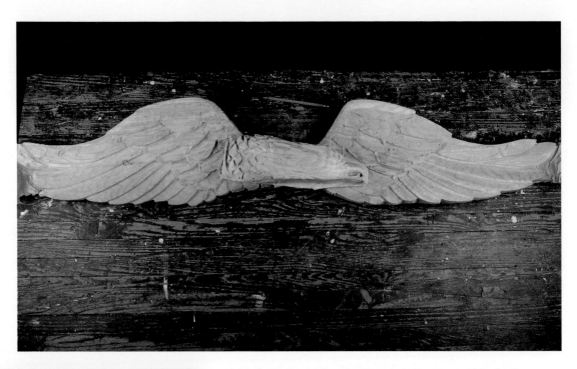

It is possible to use one of several commercial blanks for eagle carving to get to this point. Created on a duplicating machine from a carved master, they are often of good quality, and take away a lot of tedious work. This blank, which matches this project, was supplied to me by and is available from Wooden Fins & Feathers, Inc., 215 Cleghorn Street (rear), Fitchburg, Massachusetts 01420. There are several sources for quality blanks.

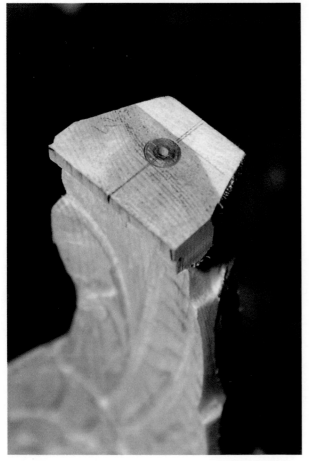

If you are using a commercially prepared blank you need to cut off the ends that were left from the spindle machine on which it was turned.

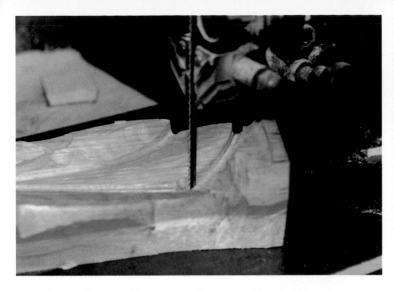

This can be cut off on the bandsaw or with a coping saw.

Use a gouge to remove the excess from the back side of the head.

Some of the excess around the head can be knocked off. The rest will be carved.

With a 3 to 5 sweep gouge remove the back side of the head that will be raised from the body.

Mark the line where the body will meet the head. The arrow reminds us of the direction the head will face.

This should take you to this roughed out position. It is the same place as we reached when we started from scratch. Saves a lot of work, huh?

19

CARVING THE EAGLE

The head in place.

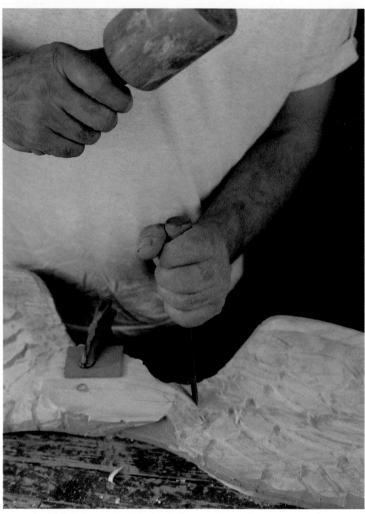

Refine the shapes of the feathers, making a relief cut around the exposed edges of each feather. One method is to drive the chisel with a mallet. When driving, remember that it is like driving a wedge. You create pressure on the wood. Therefore, you have to make sure you will not crack something that cannot take the added stress.

Continue with each row of feathers.

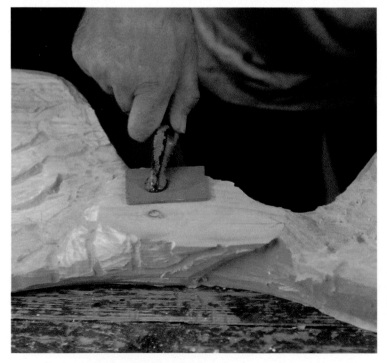

Clamp the wings to the workbench. This makes it solid, and, more importantly, allows you to have two hands on the chisel. This should always be the case.

The other method is to slice the cut. This works here where there is a long run with the grain. You will have to choose where to use which cut.

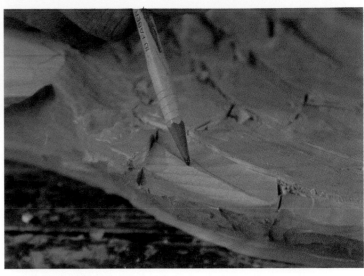

The feather surface should be curved with a high point running down the center.

When driving the tool into the line, use a gouge with a sweep that most closely matches the sweep of the curve.

You want to rough all the feathers in before adding detail.

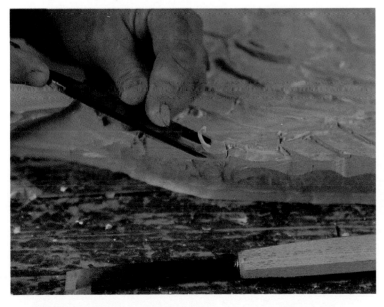

When the edges are defined, you want to use a slice cut to smooth the surface of the feather.

We need to add one more row of feathers...

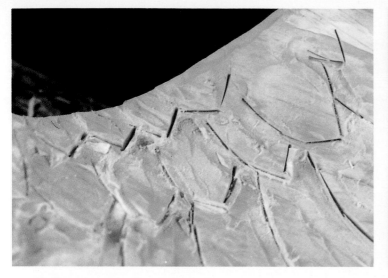

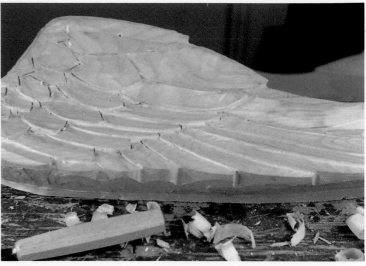

along the leading edge of the wing.

The contour of the wing has not changed much.

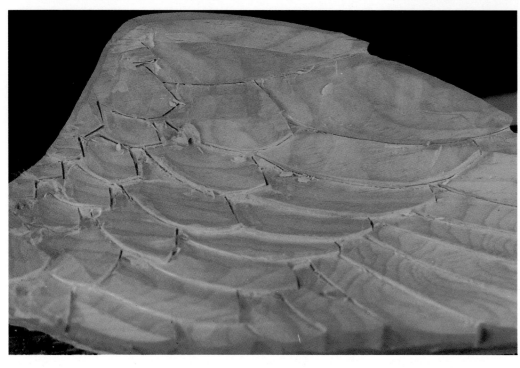

The roughed out wing. This gives us the shape of the feathers and the layering we are seeking.

If we are comfortable with the overall shape we can do the same with the other wing.

To do this we have used a 3-5 sweep gouge approximately 24 mm wide.

For the time being, avoid the neck area where the head will meet.

The slicing cut is done with the blade at a 45 degree angle to the grain.

Align the head on the neck.

As the grain shifts...

Use a couple of tacks to hold it in place. Again, don't drive them all the way in. We will pull them and fill the holes later.

you will need to change the direction of your cut.

Mark the feathers on the head...

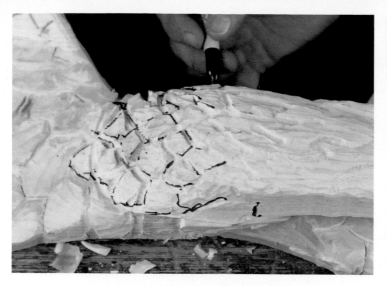

and neck. This ties the two pieces together.

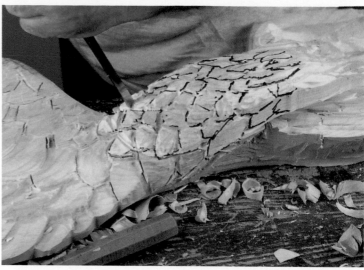

This is just a roughing in of the feathers. Remember the head is not attached, so don't use too much pressure.

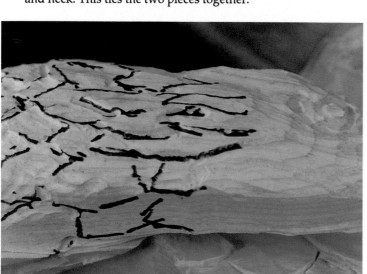

Continue up the head.

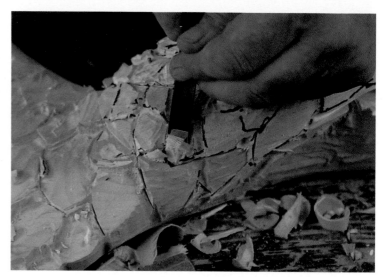

With a slice cut, smooth the surface of the feathers.

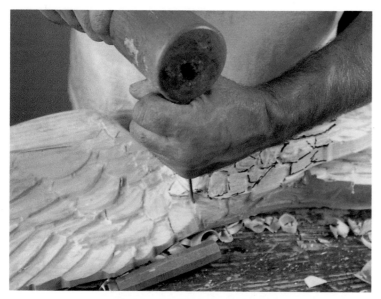

Carefully outline the feathers with the chisel and mallet. Begin around the joint of the neck and head, being careful not to hit the nails.

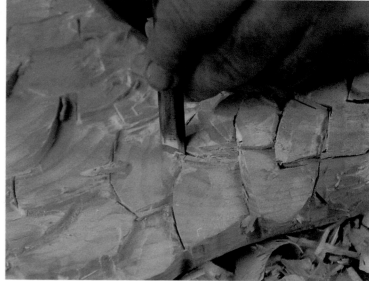

The main goal here is to get the head tied in to the body. You will then be able to remove it, do the detail work, and replace it, knowing that you have a good fit.

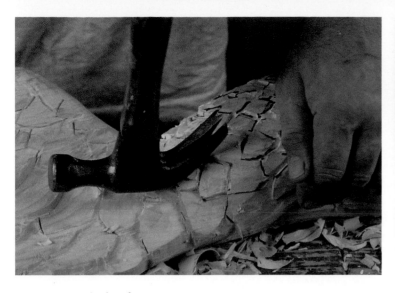

Remove the head.

Attach the head to a piece of plywood. I do this with wall board screws from the back.

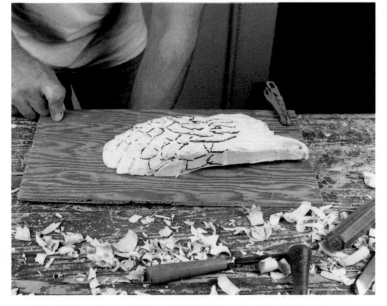

Clamp the board to the workbench.

The head is what sets the character of the eagle. The shape of the beak and the style and placement of the eye are the key elements in establishing this. Draw the top edge of the beak and make a relief cut with a gouge.

Use a chisel to smooth and round the beak. Use a slicing cut.

Make a stop at the end of the lower beak...

and slice back to it, narrowing the lower beak.

Smooth and round the top of the head.

Define the top edge of the lower beak with a slice.

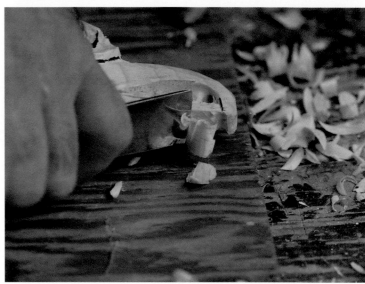

Do the same on the bottom of the head and beak.

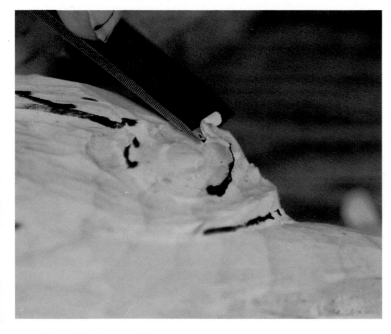

Round the brow of the eye.

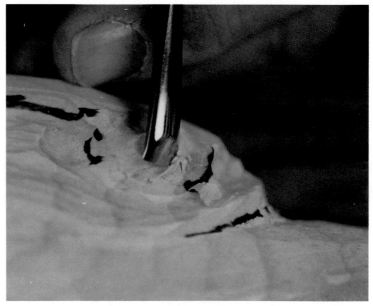

Make a relief cut around the eye, keeping the cup of the gouge toward the eye.

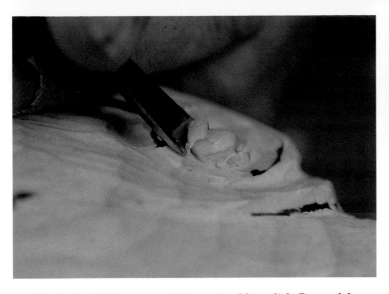

Cut back to it from around the center, like a dish. Be careful not to break the eye.

Make a relief cut along the lower edge of the brow.

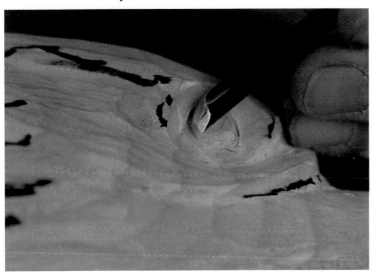

Repeat the process, taking the eye deeper and making it wider as you go.

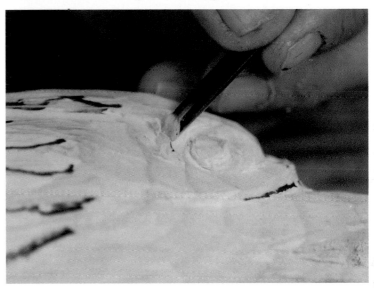

Come around the outer edge of the eye socket.

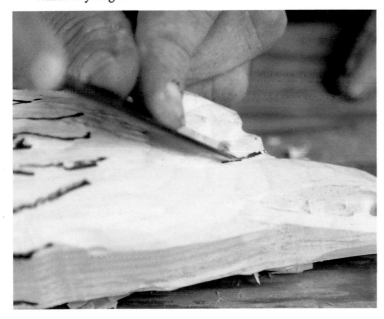

Fair up to the eye.

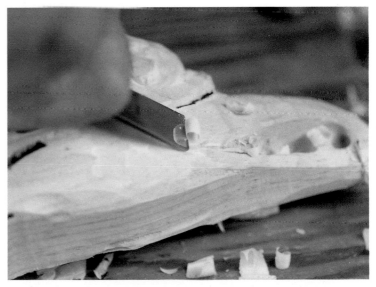

One secret, here, is to move around, and not work on the eye or the beak for too long at a time. This helps keep things in proportion with the head as a whole. It prevents you from carving a great looking eye that ends up not fitting the head.

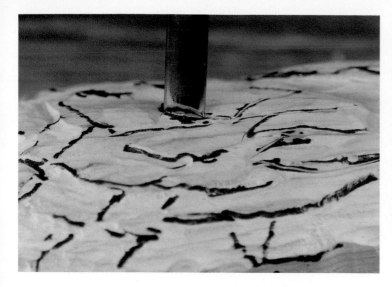

With the beak and eye roughed in we can begin to tie in the feathers of the head. Start by relieving around the feathers.

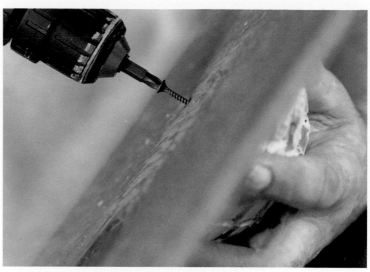

Carefully take the head off the board...

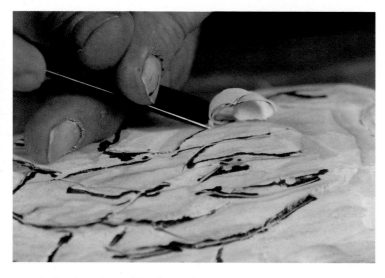

Go back and rough in the surfaces.

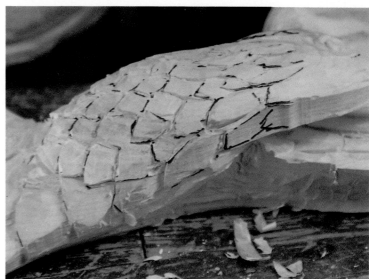

and recheck the fitting on the body. The edges are now delicate and require extra care to avoid breakage.

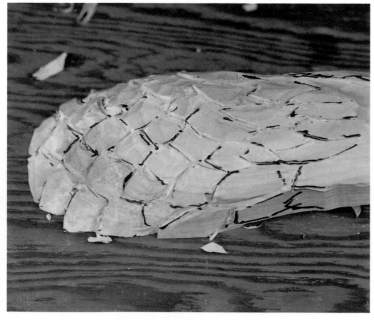

Progress. The feathers are defined and smoothed.

Mark where the head and body come together.

Adjust the body to fit the head.

Shape and smooth the area that will be under the head.

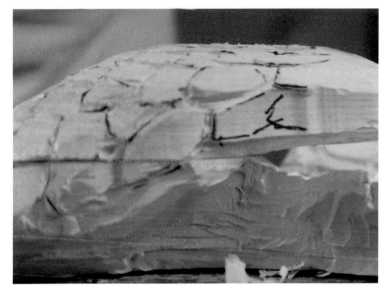

The result. Put the head aside for now.

As you finish the carving of the feathers, the skew will both help you score the edges...

Reclamp the body to the bench.

and get into the angular corners.

Smooth the leading edge of the wing.

Sand by hand or with a flap sander.

In the smallest corners a small skew is most helpful.

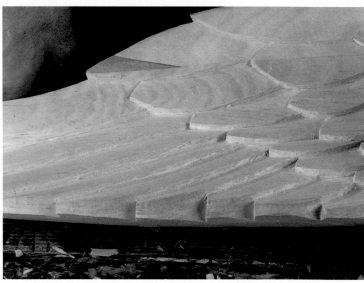

Sand the edges and blend them in to get this result.

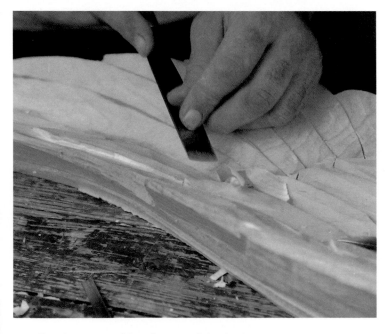

Continue smoothing the rest of the feathers.

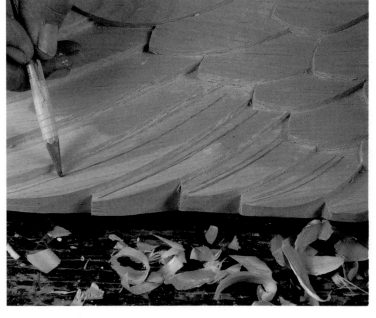

Draw in the quills of the feathers.

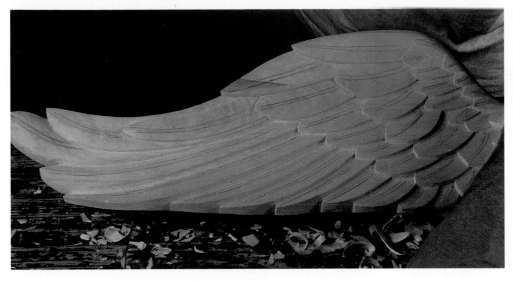

One wing complete. Repeat on the other side.

S-shaped lines move toward the quill to form the vanes of the feather.

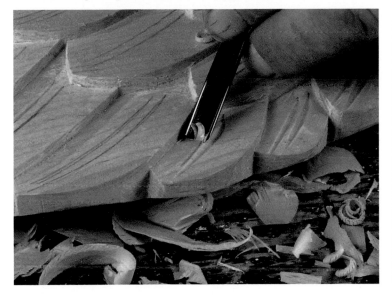

With a small v-tool go over the lines. This is where things start to come to life.

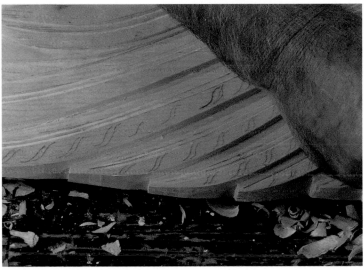

Continue on each feather leaving a pleasing distance between the vanes. I generally do all the lines in one direction before doing the other.

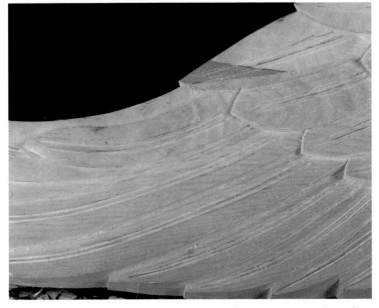

Progress

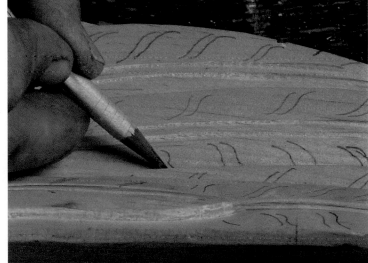

Turn the piece and draw the vanes on the other side of the quill.

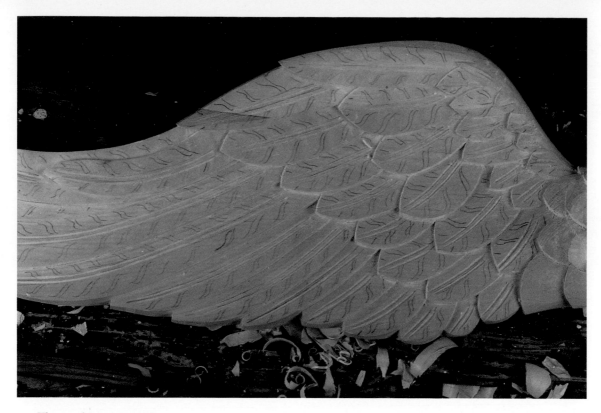

The markings complete.

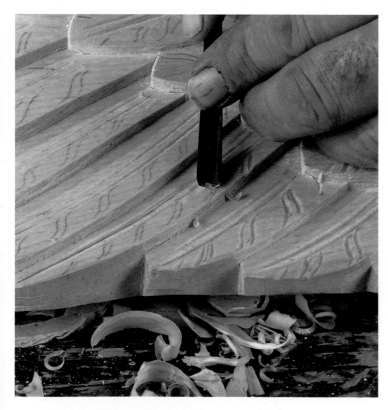

Follow the lines with a v-tool.

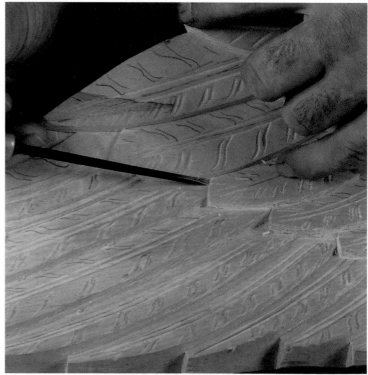

Finish the wings, cleaning up corners and other spots that may have been missed.

DETAIL WORK

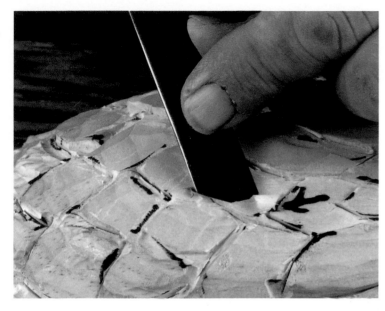

Reattach the head to the board and clean up the carving in the same way. In carving the feathers its difficult to always carve with the grain. A skew will allow you to work your way out from one of these corners while cutting with the grain.

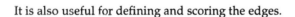

It is also useful for defining and scoring the edges.

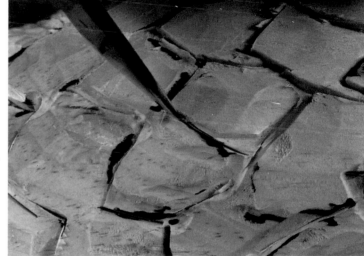

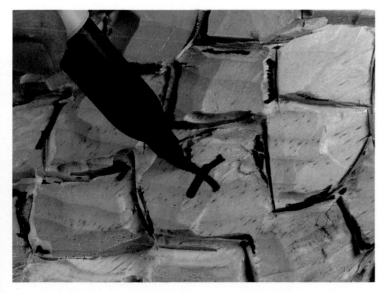

To carve these feathers involves several steps. We'll take this one from beginning to end.

With a gouge or skew we begin by defining the lower edge of the feather. Slicing straight down defines and creates a relief cut at the same time.

The feathers are interrelated, so you need to do the same steps...

Do both edges.

with all...

The result.

the adjoining feathers.

The result is that every feather is defined and relieved prior to shaping.

Do the other edge, again slicing with the grain. The result is a smooth feather, slightly rounded over the top.

Working with the grain, use a skew or gouge to shape the feather.

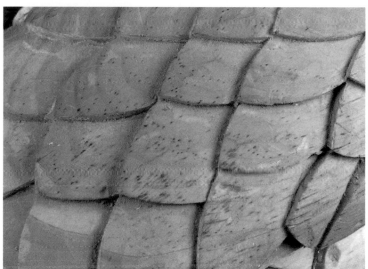

When it is finished the feathers will look nicely overlapped. The feathers next to the board will remain rough until the head is attached to the body.

Work your way toward the center, which is higher than the edge.

The front feathers need to blended into the smoother front of the head.

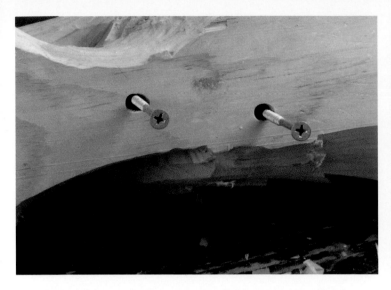

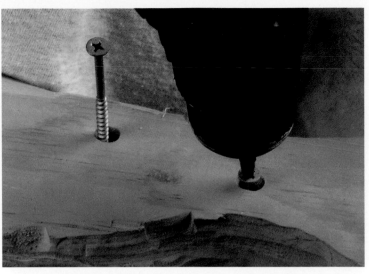

Most of the rest of the work is done after the head is glued on. Again I recommend a good waterproof glue. I often run a screw through the back to reinforce the glue joint, particularly if the piece is going outside. While the piece is tacked in place, drill a couple pilot holes to set the screws and attach with galvanized deck screws.

Put the head in place and attach it with the screws. You can do this with clamp pressure as well. Be sure to protect the wood from the clamps.

Remove the screws and disassemble. Apply glue to both surfaces, spreading to a nice even coverage.

On the feathers that are at the joint, you need to do a final blending of the head and the body.

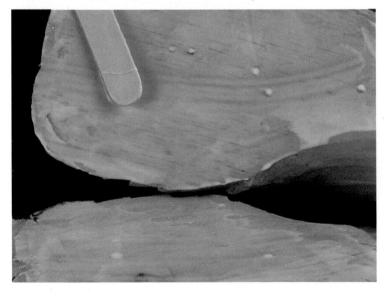

Ready for joining.

Carve right through the glue line.

Continue to shape, using a skew to get into the tight corners.

and behind the tongue.

The result. The glue line will disappear in the sanding and finishing process.

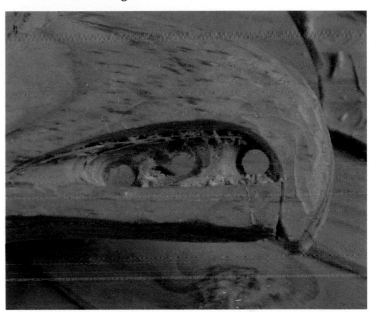

The result of the drilling. You can see that it saves labor. The attaching piece toward the front is the tongue.

Drill out the beak, here at the front...

Check your relief cut at the front of the lower beak...

and slowly...

Carry deep relief cuts along the lines of the lower...

reduce the lower beak.

and upper beak back to the corner.

Progress.

Come into the corner with a skew to pop out the excess.

Carefully work your way down, relieving as you go.

The result.

Progress.

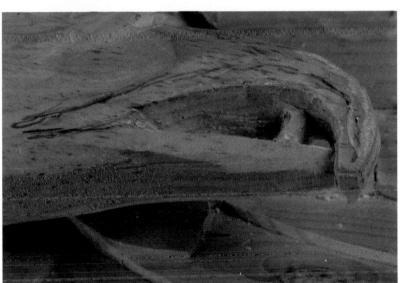

The beak needs a little definition. Mark the line...

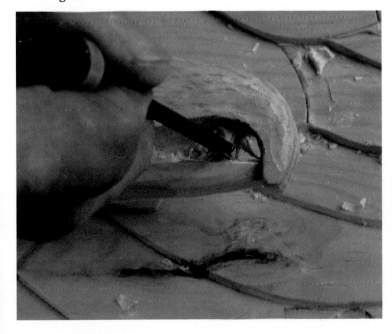

Shape the tongue.

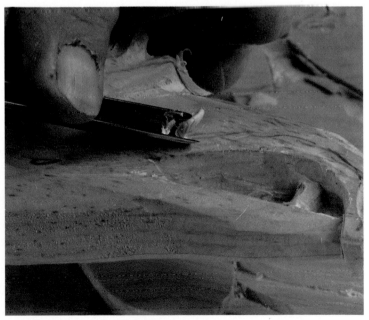

and follow it with a v-tool.

The result.

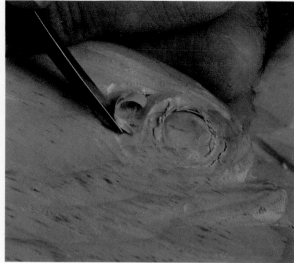

To make the eye more prominent, cut back to it from the temple with a gouge.

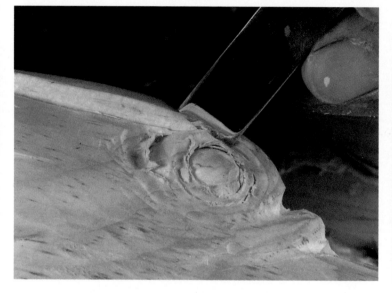

To add definition to the eye we first need to make a relief cut on the underside of the brow. Start here above the eyeball...

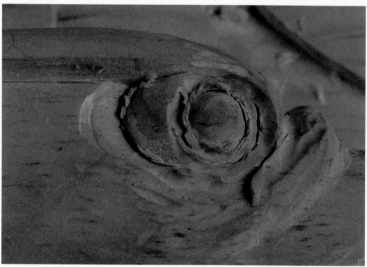

Here you can see the lift this creates.

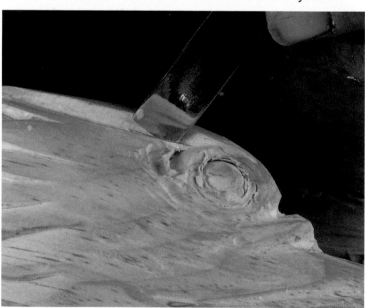

and carry the cut out to the end of the brow.

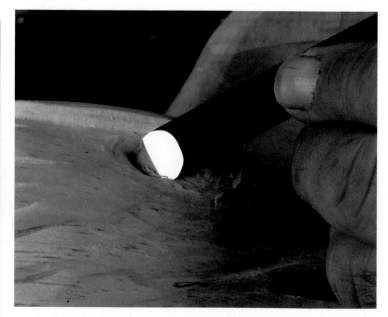

Continue the shape of the eyeball by making a relief cut along its surface...

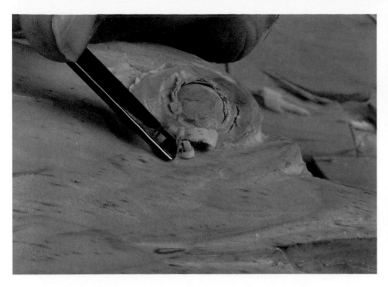

and cupping back to it with a gouge from the cheek.

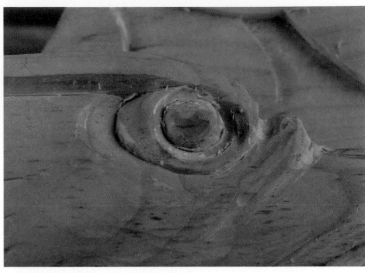

This will take you to this point.

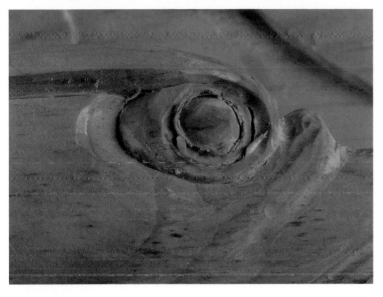

The result.

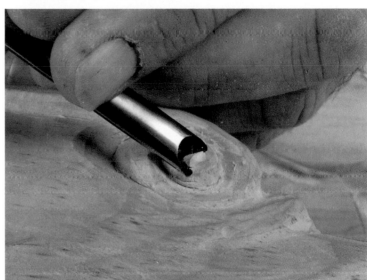

With the cup side down, round off the pupil.

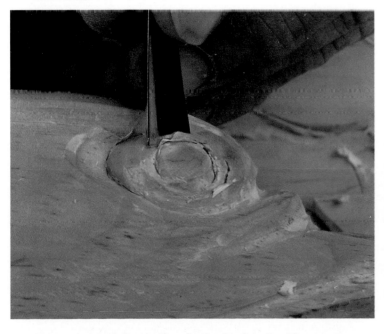

Relieve around the pupil and come back to it with a gouge.

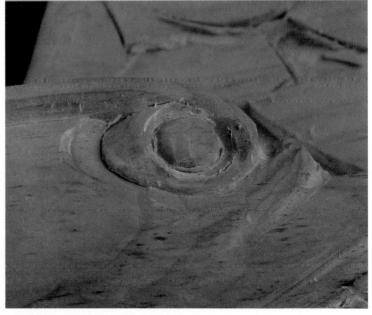

Progress.

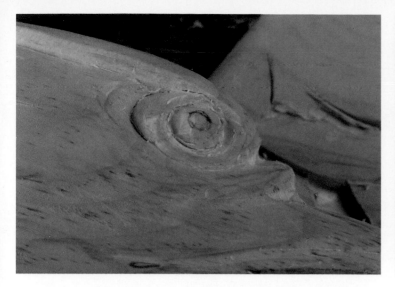

Draw the hole in the center of the pupil. This will change the character of the eagle, so start with a circle smaller than you may want. It is easier to enlarge the hole than to shrink it.

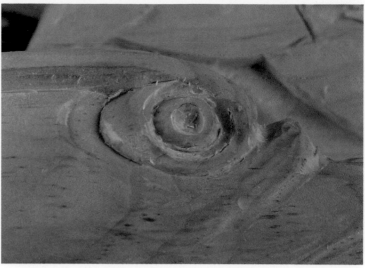

The result. Look at the whole piece and decide whether you need to enlarge the pupil or not.

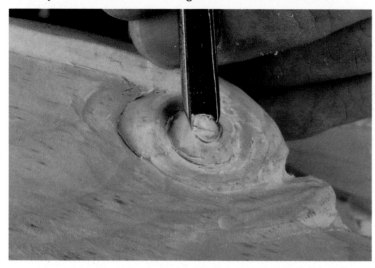

With a gouge work from both sides to remove the center.

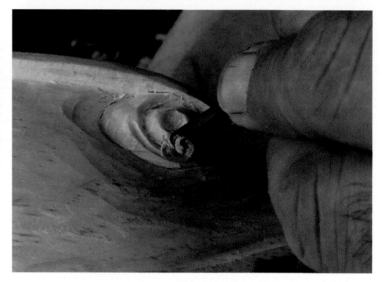

Use a v-tool to create a lid under the eye. You could also use a gouge for this cut, coming at it from both sides.

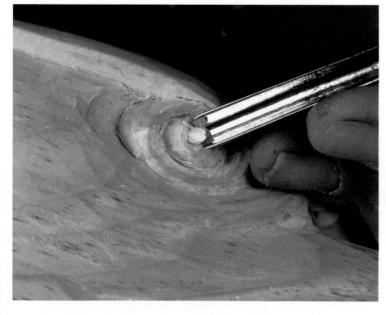

Carefully rock and move your gouge until the center pops out.

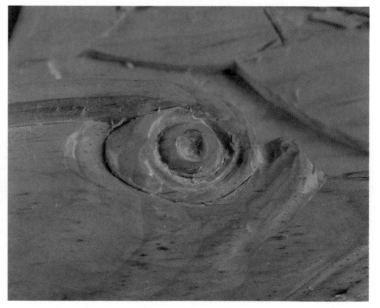

Result.

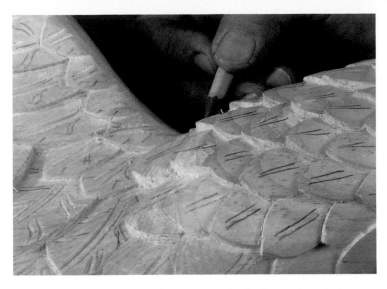
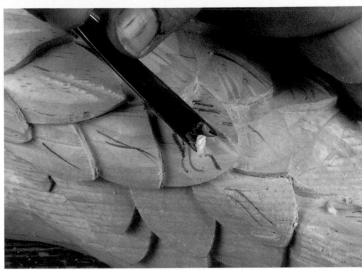

Fair the feathers from the head into the body, and mark the quills.

Cut along the vane lines with a v-tool.

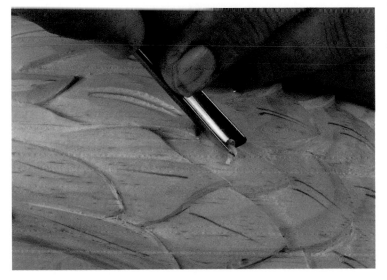
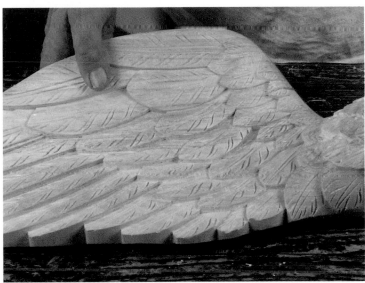

Carve the lines with a v-tool.

When the vanes are cut, you should have a smooth transition from the head to the wing

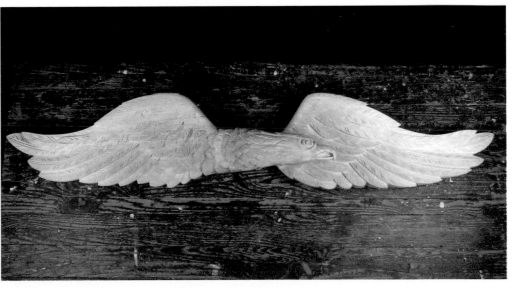

The vanes on the head feathers are similar to those on the wings. You can either draw them and cut, or cut them free hand.

Nearly ready for painting.

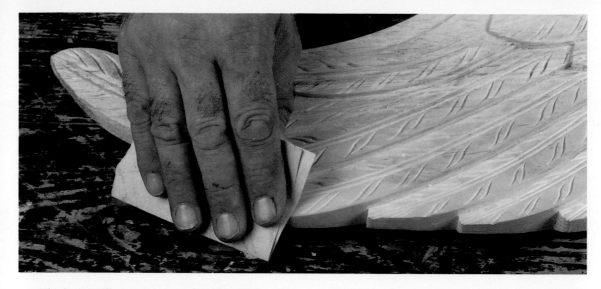

The last sanding step is to soften the edges.

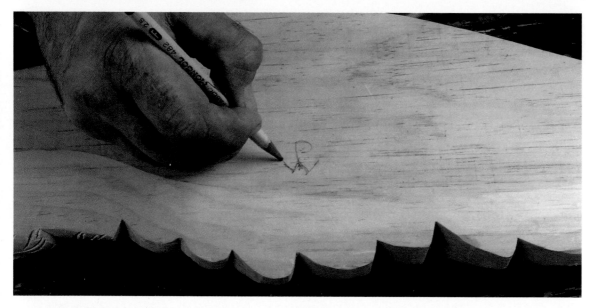

If you're proud enough of your work...

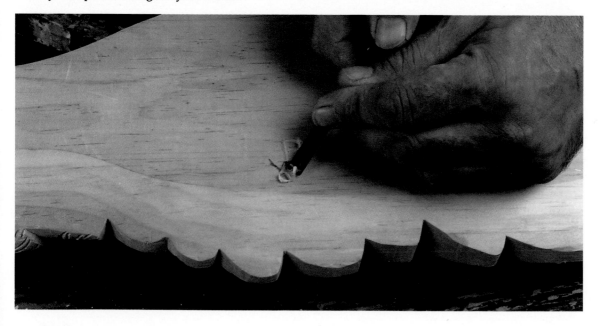

sign it.

PAINTING AND GILDING

I find it helpful to support the work on sticks for painting.

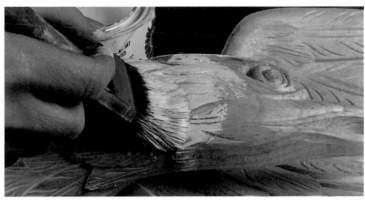

Draw the paint out to avoid puddling. Sand lightly with a fine grain paper and apply of second coat of primer, full strength.

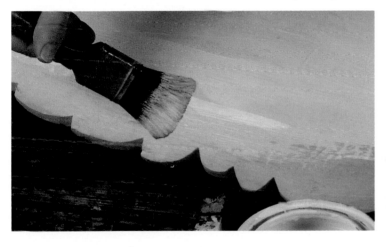

I use an exterior oil-based house paint thinned approximately 10%. Start on the back.

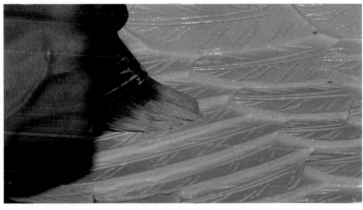

When the primer coat is thoroughly dry, paint the final coat with an exterior gloss white oil-based paint and it will be ready for gilding.

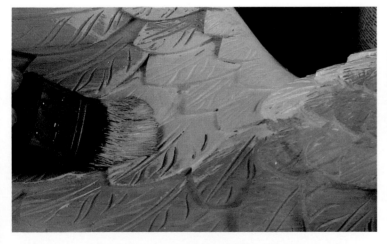

Make sure you get the paint into the carvings. This is the seal coat and you need to get complete coverage.

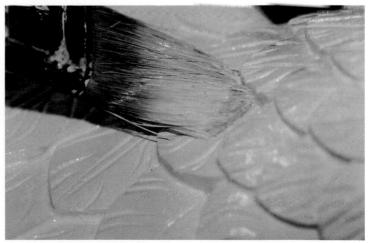

Be sure to pull any paint blobs from corners and carvings.

GOLD LEAF

To make gold leaf, a nugget of real gold is worked to a thickness of 1/200,000". This is formed into sheets that measure approximately 4" x 4" and come in "books" with a sheet of tissue paper between each leaf. This are applied to a surface that has been painted with sizing, a varnish-like material. Called oil size, it is a product designed particularly for gilding. It provides a smooth, adhesive surface for the gold leaf. It comes in two varieties, the quick dry oil size, which we use here, and a long dry size, which has the advantage of a larger window of time for applying the gold leaf. This is critical because the most important factor in successful gold leafing is laying it down when the tackiness is just right.

If you put the leaf on when the size is too wet, it will wrinkle and bleed through and generally look terrible. If it is too dry it will not adhere properly. The tendency is to lay it down when it is too wet. With the quick dry size you have a window of about twenty minutes. With the long dry the window is longer.

When you purchase gold leaf buy two or three books of surface gold (loose leaf) containing 25 sheets. It needs to be 23 karat gold for outside use. I would recommend you always use this quality. Gold leaf with a lower karat will have more trace metals and will oxidize and tarnish more quickly. A good layer of gold leaf will last 15-20 years. Gold leaf can be found at some art supply houses and from sign suppliers.

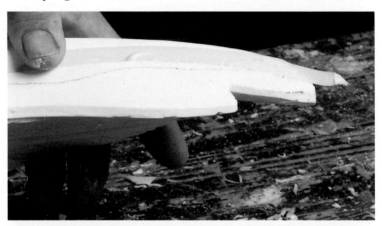

Quick size an area that you can reasonably cover with gold leaf during a 5-10 minute period. I apply the sizing quickly but evenly so that the whole area will have the same window of opportunity. The size has a few drops of yellow tint to make it easier to see the coverage. Each eagle is different, and this one has a very thick wing. I have chosen to carry the gold leaf back to this line...

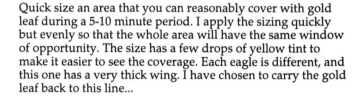

which I mark with tape. This will be the limit of the sizing.

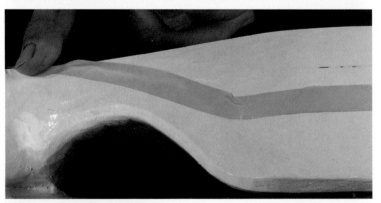

I start to apply the sizing on the back edge of the wing.

On the bottom edge I will cover the whole surface.

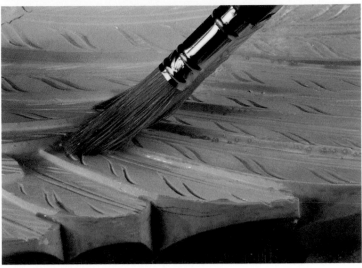

Work the sizing with the brush to get a nice thin complete coverage and no puddles.

Carry the sizing to the end.

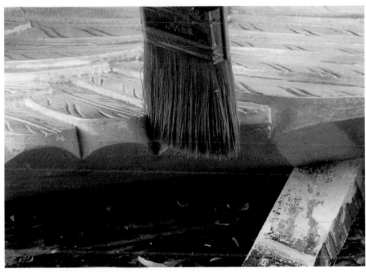

Don't forget the edge.

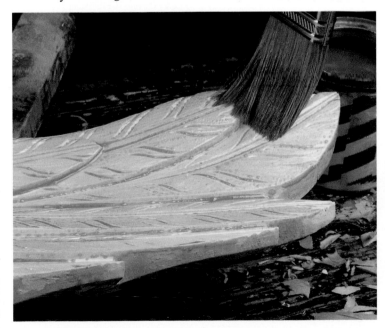

On the front surface cover a small section.

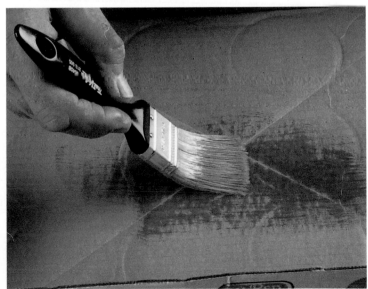

You want to dry brush the sizing to be sure you have no puddling. You may wish to get the excess sizing out of your brush by wiping it on a piece of cardboard or scrap.

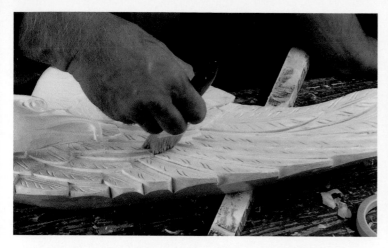

Continue drybrushing until the puddles are gone from the details. You should be able to see this. If your brush is not effective in pulling these puddles out, it is too wet. Wipe it off and try again.

Apply some size to a test board that has been painted in the same way as the eagle. I run four strips, as thin as the coating I put on the eagle. With these I can test for tackiness without leaving fingerprints in the eagle.

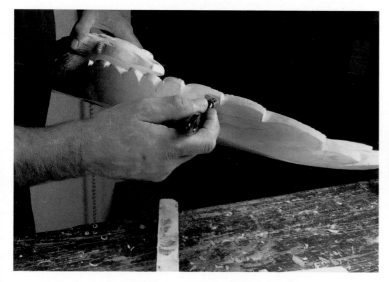

Go back and check for sags and drips. This is a thin material going over a gloss white, so running and sagging is something you have to check.

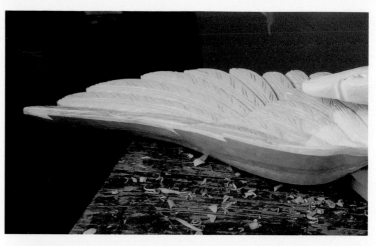

When you have sized as much as you can gild during the window of time while the piece is at the right tackiness, put the piece aside to allow the size to set up.

I number the order in which I laid down the test lines. The tendency is to go too early. Very early application of gold leaf will cause wrinkling and crinkling or will be dull or flat looking. Semi-early application will cause bleed-through. It is possible to go too late, but this is not a common a problem for most people. If you do, the gold leaf will not stick. If this happens you simply allow the sizing to dry completely (a few days) and try again.

The size is ready when you can still feel the tack but barely. It *should not* leave a fingerprint. It is less tacky than the adhesive on a post-it note. Use the test board for checking.

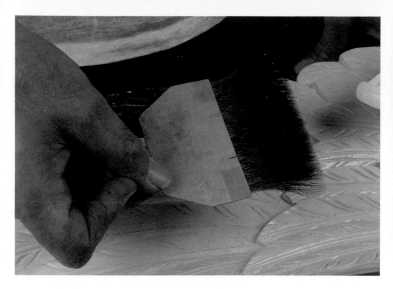

Because we have a large area to cover and want to remove large sheets of gold, we use a gilder's tip.

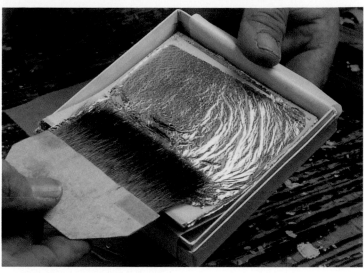

This is enough to pick up the gold. Lay the brush so it overlaps the sheet of gold.

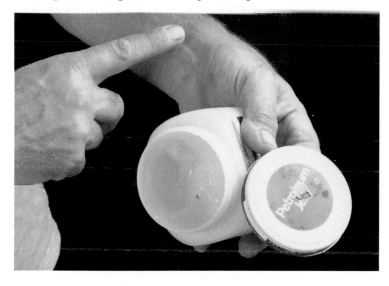

This is static gilding. Place a minuscule amount of petroleum jelly on the inside of your wrist.

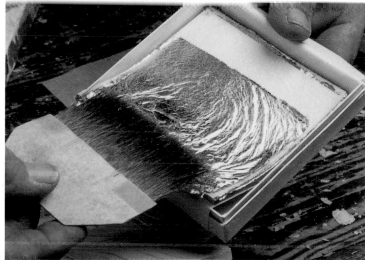

Pull the gold out of the book...

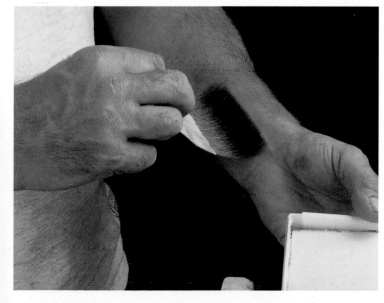

Rubbing the brush across the petroleum jelly transfers the slightest amount of it to the brush.

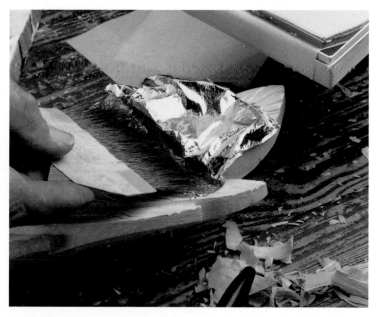

and lay it on the wing.

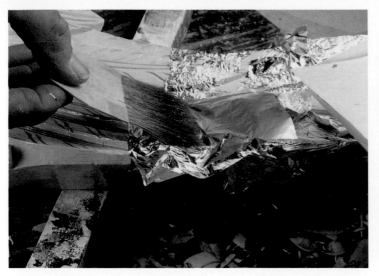

Continue laying whole sheets.

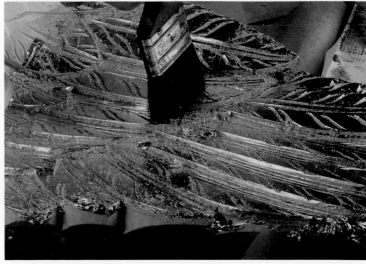

to work the gold into place.

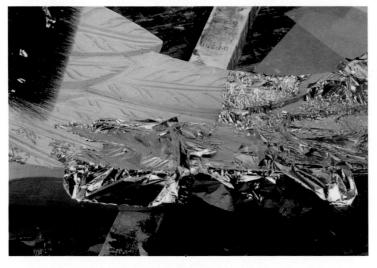

The sheets should overlap slightly.

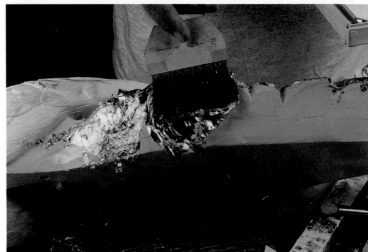

Do the top of the wing...

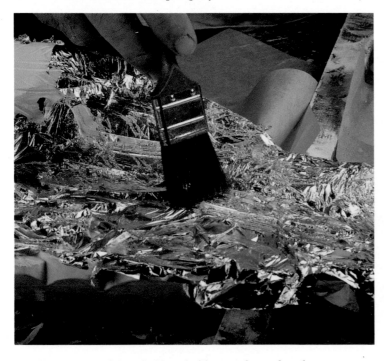

Use a very soft bristled brush, like a make-up brush...

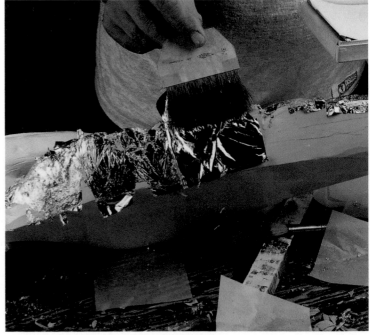

in the same way.

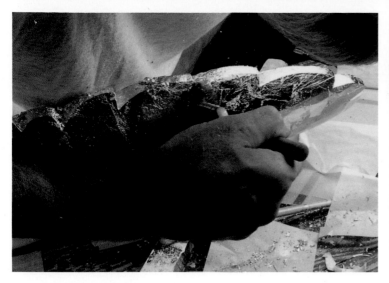

Work it in with the brush.

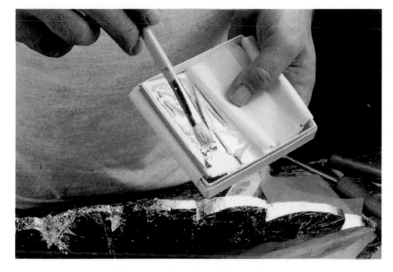

A stiff bristled brush can be used to pick up small pieces of leaf to fill in the gaps.

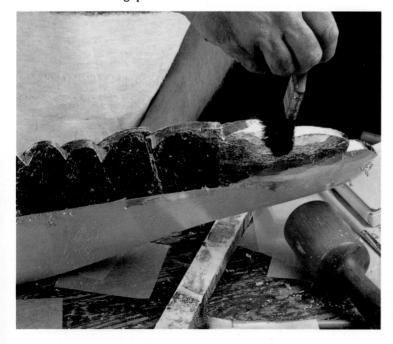

Work everything in with the soft brush.

I usually gold leaf over a box that collects a lot of the excess. This is then reusable for filling in some gaps.

Here I collect the excess. If you get enough of this excess you can send it to a refiner and get some money back, but it will take two or three years of gilding before it amounts to enough to be worth while.

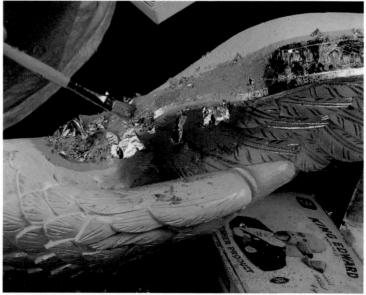

Continue with the top edge of the wing.

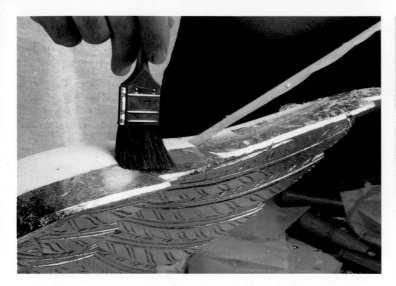

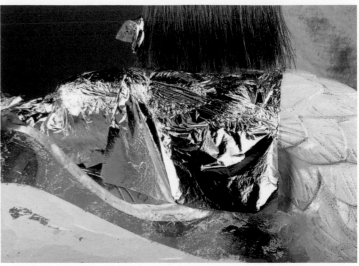

When the leaf is in place, remove the tape and brush the leaf into place at the same time.

Continue to work your way toward the neck.

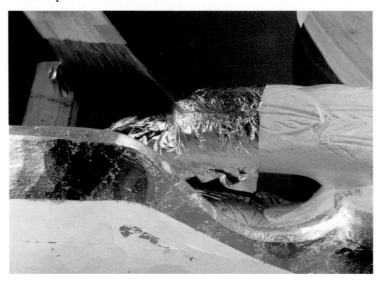

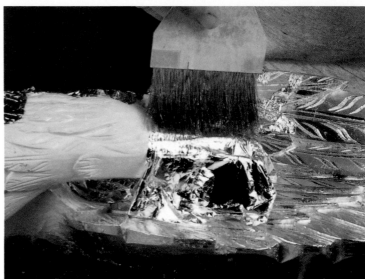

After completing the wing apply size to the head. When it is ready, continue the gold leaf. I begin at the top of the head and work from the beak toward the back.

When the top edge is done, do the bottom of the head. Again, I start at the beak...

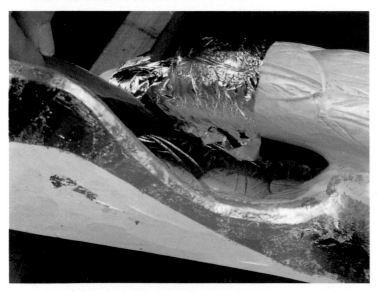

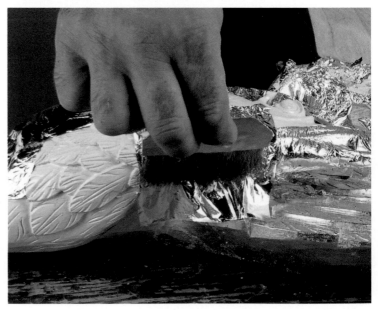

With the raised head it may take a little work to get the leaf in the space between the wing and the head.

and work back.

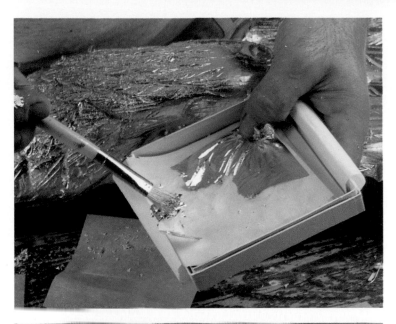

As before, for filling gaps I use a stiffer brush to pull a small piece of gold leaf from the book.

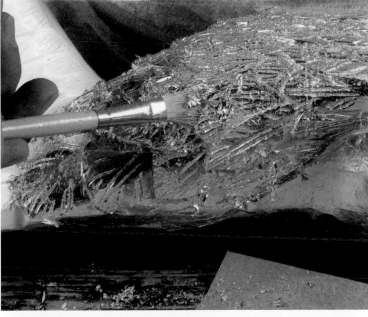

Apply the gold to the gap.

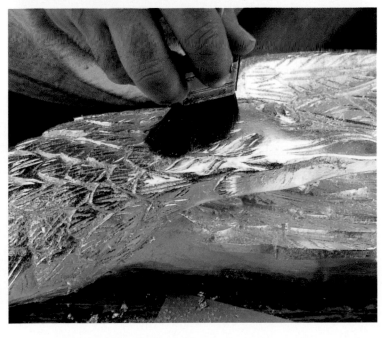

With this kind of gold leaf only a light burnishing is needed now, but a heavier burnishing should only be done after many weeks of "curing". Let the piece hang, inside or out, for a month or two. Then bring it in and lightly brush away any excess.

GALLERY

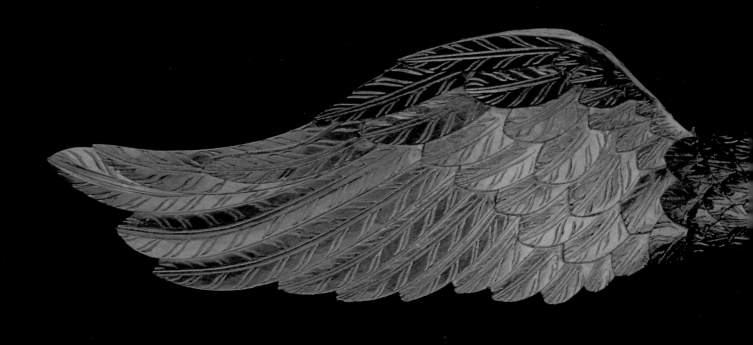

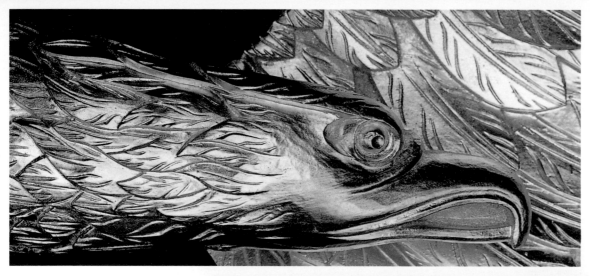

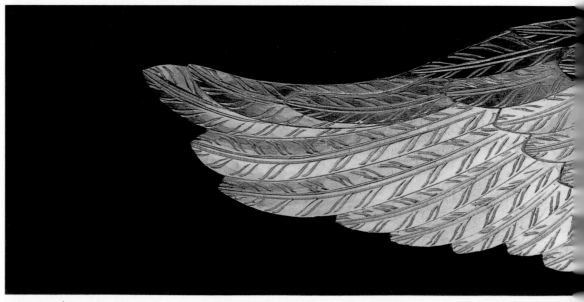

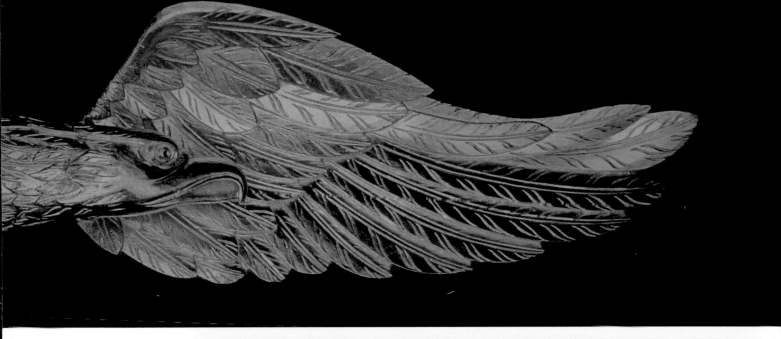

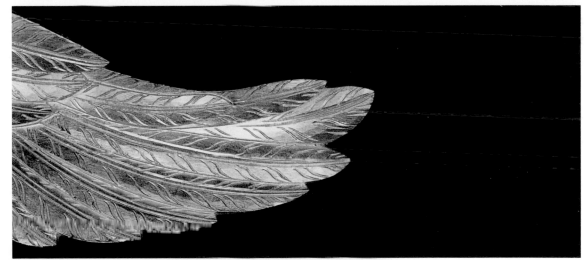

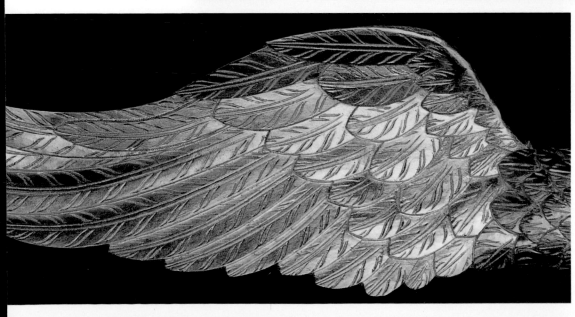

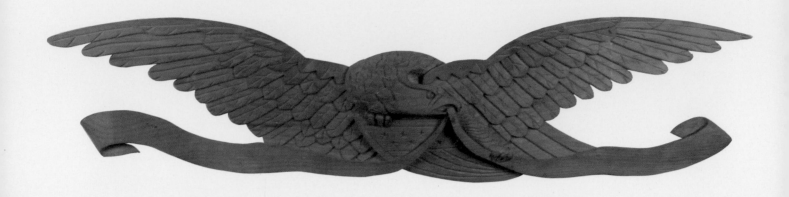

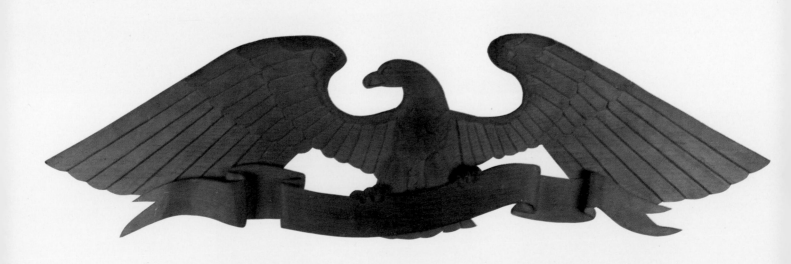

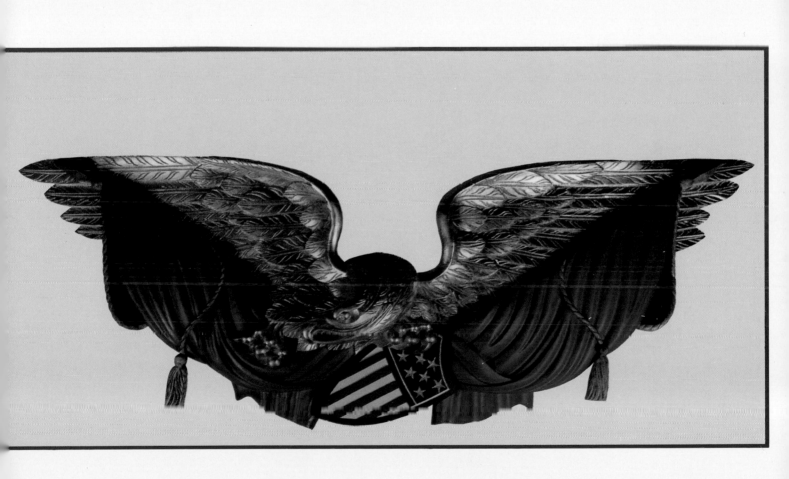

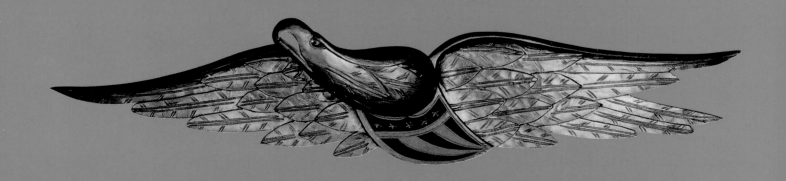

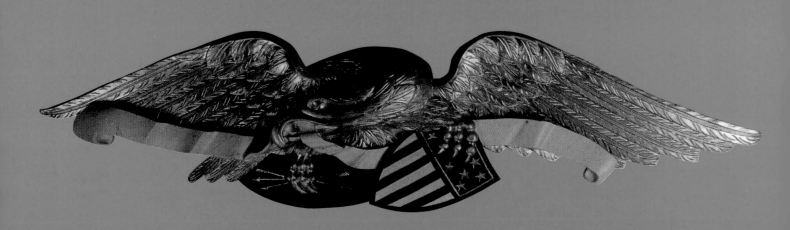

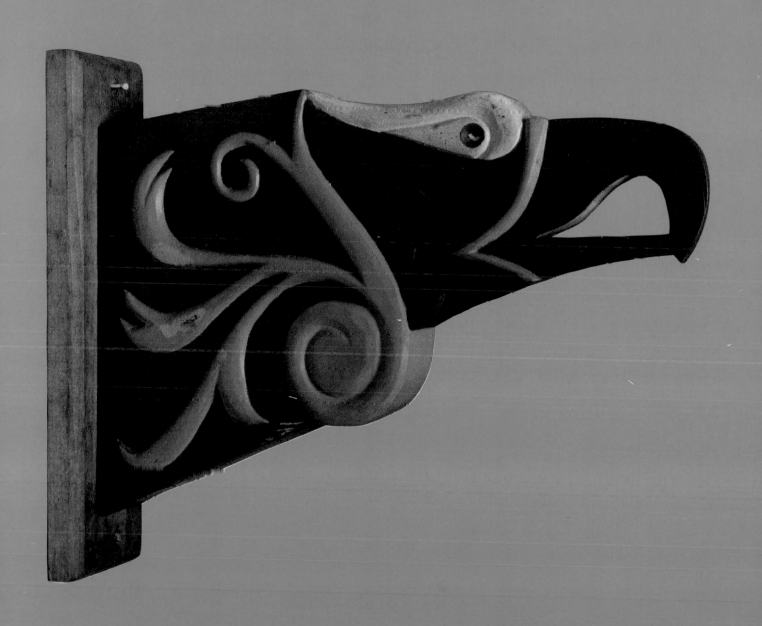

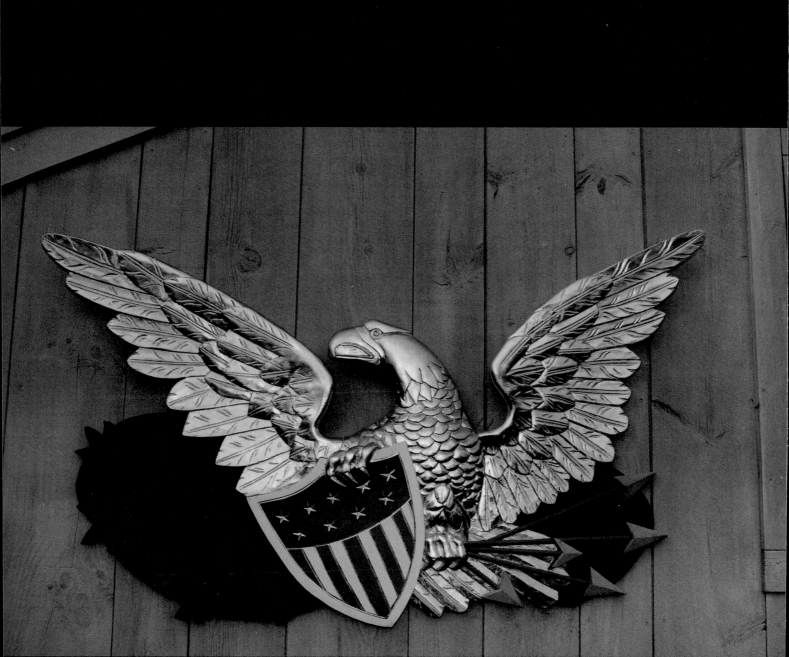

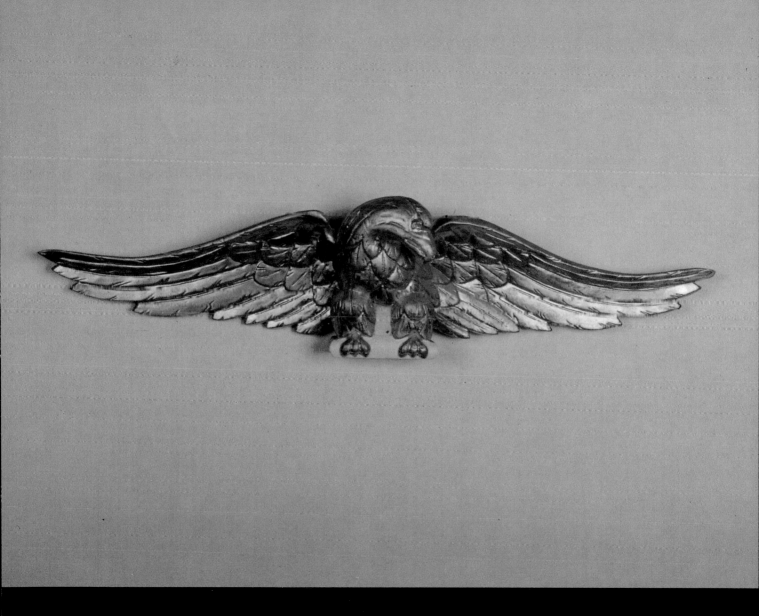

BIBLIOGRAPHY

Smith, Yvonne Brault. *John Haley Bellamy, Carver of Eagles.* New Hampshire: Portsmouth Marine Society, 1982

Hornung, Clarence P. *The American Eagle in Art and Design.* New York: Dover Publications Inc., 1978.

Cousins, Frank and Phil M. Riley. *The Woodcarver of Salem.* Boston: Little, Brown, & Co., 1916.

Isaacson, Phillip M. *The American Eagle.* Boston: New York Graphic Society, 1975.

Wheeler, William. *Practical Wood Carving and Gilding.* London: Evans Brothers Limited. 1963

LeBlanc, Raymond J. *Gold Leaf Techniques.* Cincinnati: Signs of the Times Publishing Co., 1961.